Sparkle Explains Baroque Art

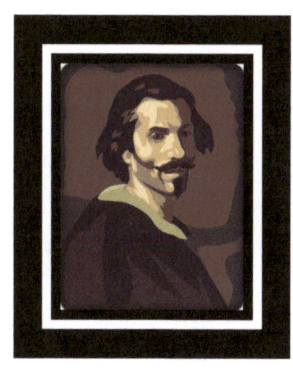

For my handsome husband Ted, thank you for all you do! I love you so much. Always, E

Hi! I'm Sparkle. Although I might be a small dog, I know a lot, especially about one of my favorite subjects—art. I like to look at art, to learn about it and especially to do art projects.

I learned about art history and watched professional artists at work.

One of the best ways to do something new is to learn from a professional. A professional is someone who does it or did it for a career. In fact, learning from

someone who knows the most about a subject can teach you a lot more than googling how to do it.

I might not have learned so much about art if it weren't

for the age of Baroque. I learned that Baroque art opened the door for everyone to enjoy art and all of the beauty associated with it.

This period in time only lasted about 150 years from 1600 to 1750. With the push of the Catholic Church, Baroque changed the direction of art and aimed it at everyone rather than a few people.

The art movement before Baroque was called Mannerist.

As manners are formal and proper, so is Mannerist art. It showed a narrowed perspective. Baroque art came along and turned everything from music to buildings into a new style.

This happened at the end of the Renaissance and Reformation period which was a time of rebirth.

Around 1600, history moved from the rough Middle Ages with Knights jousting

to the Renaissance in the 1400's.

Baroque art used the achievements and advancements of the Renaissance. The word Baroque is pronounced "bar oak". It began when a man named Johan Winckelmann compared the very advanced art of his past to the art of his day. He thought it didn't have the grandness of earlier

art. The word Baroque meant a tooth or pearl of unequal size.

Nevertheless, Baroque art used exaggerated motion and intense detail s. This artistic style produced drama

tension, passion, and grandness in painting,

sculpture, architecture, literature, dance and music.

Baroque art changed many aspects of life.

One of the first major changes started in art forms. An artist named Heinrich Wolfflin altered the focus of art from a circle to an oval

shape as the center of attention

Baroque used a main subject, often referred to as centralization Previously, artists liked balanced composiiton; then Mannerists ctreated more tension than balance in art For example, Michelangelo's The Creation of Adam

painting focuses on the magical point between God and Adam's finger.

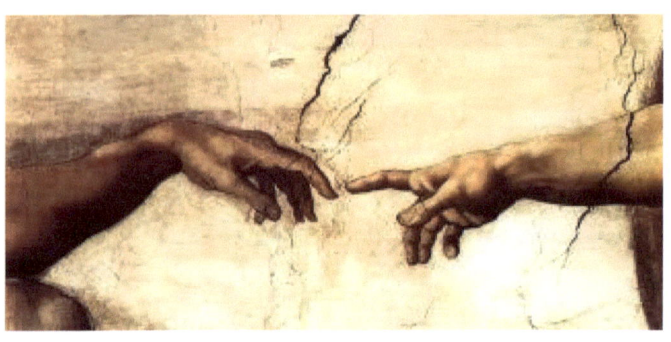

Michelangelo and other artists during the Mannerist period painted with the

plaster on walls. This medium is called fresco painting. As you can imagine, this style softens the colors and adds texture.

Michelangelo painted for many years and as a result, early signs of the Baroque can also be found in his work.

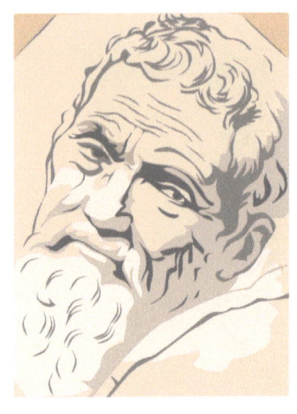

Michelangelo Buonarroti

Michelangelo Buonarroti was one of the most famous Renaissance artists. Although he was best known

for his paintings, he considered himself a sculptor.

He was an architect and poet also.

Renaissance artists tried many art forms. The Baroque went even bigger and bolder. Paintings showed brighter colors. At this point in time,

paint strokes began to show more.

Baroque art touched many aspects of art and peoples' lives. Music developed into Baroque music. How people designed

buildings became known as Baroque architecture. Baroque influenced and transformed society.

The Roman Catholic Church promoted this style of art in

response to the Protestant Reformation when Catholics turned protestant. The church persuaded art and literature to show the importance of religion for them. The Council of Trent decided that the arts should connect to their audiences' emotions with religious themes.

In order to reach people and influence their thinking, the council stated the arts, paintings and sculptures, should speak to the poor and non-educated people rather than the rich and educated person.

This change of audience made the artwork evolve into an inspirational form of art. Each piece told a story. Baroque art appealed to

people because it made senses to them.

The Mannerist artists before Baroque period focused their attention to educated people. At the time, not very many people went to school, so the artists' audiences were limited to very few people. Other people didn't have the chance to see such works of

art because they didn't travel or have the money to visit fancy places. Furthermore, if they did see the art, it was so intense that it didn't make much sense to average people. Mannerist art tried to be witty and came off as snobby to some folks.

The Baroque style appealed to people because it told a

more understandable story. Often Baroque art often included a hero.

In Baroque music, there are contrasting phrase lengths, harmony and counterpoint . Orchestral instruments made

a strong appearance.

Usually, art historians divide the Baroque period into three phases

- *Early Baroque, c.1590–c.1625*
- *High Baroque, c.1625–c.1660*
- *Late Baroque, c.1660–c.1725*

Late Baroque also is called the Rococo movement. Rococo was the height of being fancy and light in art.

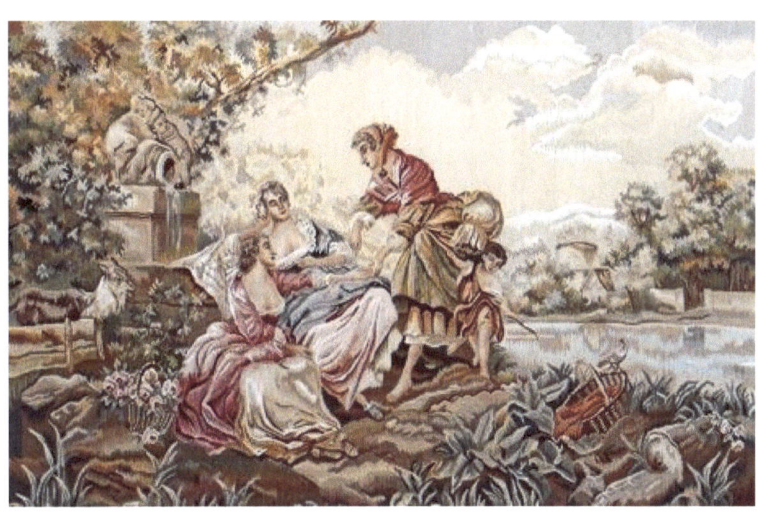

Francois Boucher painted romantic, often mythological scenes. He was one of the best known Rococo artists. He created hundreds of paintings, book illustrations, theater designs and tapestries.

Tapestries are fabric pieces which show a picture and often tell a story. It is old

French for heavy carpet. Tapestries are woven still today.

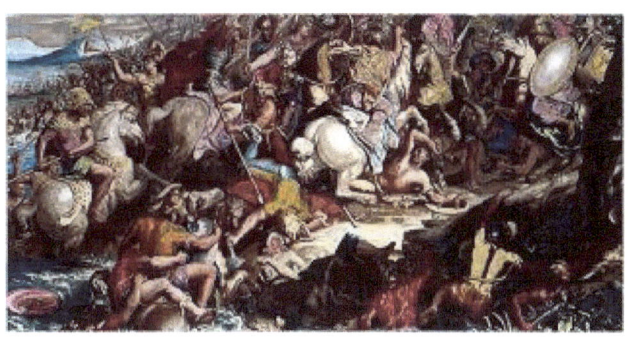

Additionally, people still buy Baroque style furniture. The decorative styles come and go

in fashion and Baroque makes an appearance from time to time.

As it were, interiors, paintings and the decorative

arts, of the Baroque style continued to be used in architecture until the Neoclassicism.

Architecture became important because it created

business areas called urbanization.

Baroque represented so many aspects of life from furniture to its roots of painting.

A defining statement of what Baroque signifies in painting is provided by the

series of paintings by Peter Paul Rubens.

Peter Paul Rubens was born in Siegen, Germany on June 28, 1577. His paintings were rich in detail as well as subject matter. He used vivid colors to bring extra life to his works of art. Often, his

detailed paintings told stories, called allegories.

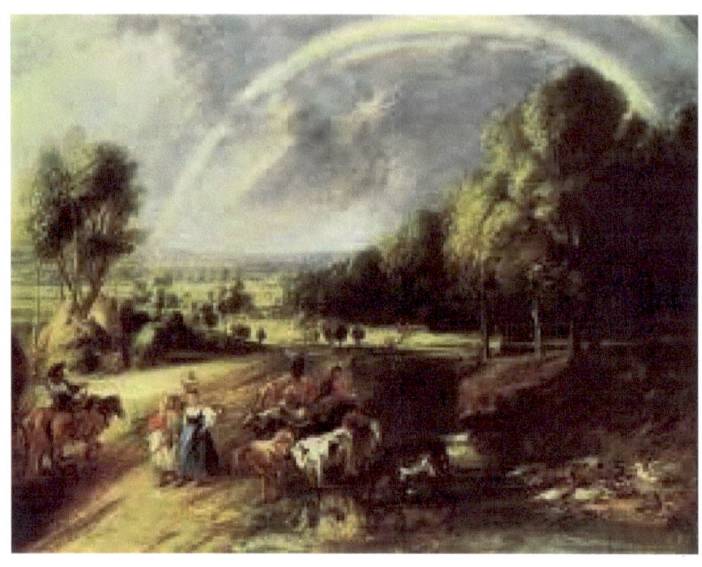

For our project, let's create something in the Baroque style of art. Like Peter Paul Rubens, we can retell a favorite story. Think of a story, including the characters, and setting. Think of the mood to relate the colors. Is the story happy and sunny like yellow or sad or mysterious like dark blue?

Visualize the scene in your mind. If it doesn't come out like you imagine, that is fine! Art isn't supposed to be perfect. It is an expression of yourself.

You need to get your supplies ready ahead of time so you know you are prepared. Cover your work area with recycled paper.

You will need:

Paint, brushes, paper, water, a throw away paint cup and recycled papers

Think of a great scene in a book or movie, like Percy Jackson battling Medusa or Harry Potter on a giant troll's shoulder as he shoves a wand up its nose.

On construction paper, use watercolors to paint the main character in the story. Place the character in the story's setting, with details

that reflect their ideas. Make the character as lively and colorful as possible, just as Rubens did in his allegorical paintings.

When you finish, keep your painting in your artist portfolio.

Good job!

www.ingramcontent.com/pod-product-compliance
Lightning Source LLC
Chambersburg PA
CBHW040925180526
45159CB00002BA/616